ARTISTS SPEAK

ARTISTS SPEAK

A Sketchbook

Eric Maisel

HarperSanFrancisco
A Division of HarperCollins*Publishers*

ARTISTS SPEAK: *A Sketchbook*.
Copyright © 1993 by Eric Maisel.
All rights reserved. Printed in the
United States of America. No part
of this book may be used or
reproduced in any manner
whatsoever without written
permission except in the case of
brief quotations embodied in
critical articles and reviews. For
information address HarperCollins
Publishers, 10 East 53rd Street,
New York, NY 10022.

FIRST EDITION

ISBN 0–06–250880–6 (pocket ed.)
ISBN 0–06–250881–4 (journal ed.)

93 94 95 96 97 ❖ HCP–HK

10 9 8 7 6 5 4 3 2 1

This edition is printed on acid-
free paper that meets the
American National Standards
Institute Z39.48 Standard.

Introduction

Over the centuries, artistic creativity has been variously attributed to divine inspiration, madness, intuitive genius, unnameable life forces, and cosmic forces.

In modern times, it has been linked to unconscious processes, social roles, the sublimation of sexual instincts, attempts at wish-fulfillment, and incipient neurosis. It has also been linked to the natural associational tendencies of the mind, the self-actualizing efforts of the individual, and the existential ability of some persons to rebel, witness, and be free.

It may be most useful to define creativity in terms of engagement, because the artist loves what she is doing, knows what she is doing, and has faith in what she is doing—in the committed activity we call art-making. The three elements of creativity, in this view, are loving, knowing, and doing; or heart, mind, and hands; or, as Buddhist teaching has it, great faith, great question, and great courage. To be

creative, artists are thus challenged to love enough, know enough, and do enough.

Artists fall in love with and are transported by the medium in which they work. They're "delighted and astonished," as Frédéric Chopin suggested, to learn that their medium has this power to transport them. That it has this ability is proof for some of the existence of God; it is certainly a special affirmation in the realm of the spirit.

As a young person the artist soaks up everything about a chosen medium because he or she has fallen in love. Much of an artist's knowing comes from this early time. The young blues singer listens to all of Billie Holliday's records and begins to learn the blues. The young writer reads all of the works of Dostoevski and learns about literature's extraordinary power.

This knowing is both intuitive and rational, tonal and factual, conscious and unconscious. During this time, and all throughout life, the artist is challenged to know enough, to take in all that is necessary for her to take in, even if, in the language of Zen, one must forget much of what one knows in order to work.

This is a knowing based on immersion. If you are an actor you immerse yourself in a role, living and breathing the character. If you're a dancer you become the deer, the swan. As a writer you live right inside your novel.

Artists are immersed in different waters, to be sure, their art reflecting these differences. Be it abstraction or realism, jazz or traditional Andean flute music, each, insofar as he or she is deeply creative, is deeply immersed. As the psychologist E. W. Sinnott said, "Inspiration, it is well recognized, rarely comes unless an individual has immersed himself in a subject. He must have a rich background of knowledge and experience in it."

If loving is the heart of creativity and knowing is the brain, doing is the musculature. Doing is both effort and execution. A person is not an artist until she works at her art, no matter how eloquent she sounds during the cocktail hour or how fine are the images that come to her mind. As David Salle, the visual artist, put it, "It's easy to be an artist in your head."

Artists know this. They realize often enough that they aren't able to translate their visions into

splendid art. Even the finest artists write books, paint pictures, give performances, and involve themselves in projects that are not great. The artist can only try.

I hope that the following quotes will inspire you to try. I also hope they provide you with the pleasure of recognition, for you'll find in them reflections of the creative spirit that already resides within you. When you love what you are doing, know what you are doing, and do it faithfully, a confidence is bred in you that is the best stretcher of limits.

If it is art, it is not for all.
If it is for all, it is not art.

—*Arnold Schönberg,*
composer

I should like to endow color with intoxication,
fullness, excitement; I should like to give it power.

—*Paula Modersohn-Becker, painter*

I love close-ups. The closer a camera comes,
the more eager I am to show
a completely naked face.

—Liv Ullmann, actress

There is no "must"
in art, which is
ever free.

−*Wassily Kandinsky,*
painter

I feel that with every
piece I get further
towards being able
to write what is
really in my heart,
and in fact that
is the only rule
of conduct I have.

—Felix Mendelssohn,
composer

A woman who has lived many things and who sees
lines and colors as an expression of living might say something
that a man can't. I feel there is something unexplored about
women that only a woman can explore.

—*Georgia O'Keeffe, painter*

In the end we shall have had enough of cynicism and skepticism and humbug and we shall want to live more musically.

—*Vincent van Gogh, painter*

I consider that
every artist who
isolates himself
from the world
is doomed.
I find it incredible
that an artist
should wish to
shut himself away
from the people.

—*Dimitri Shostakovich,*
composer

As a musician
I tell you that
if you were to
suppress adultery,
fanaticism,
crime, evil,
the supernatural,
there would no
longer be the
means for writing
one note.

—*George Bizet,*
composer

I really don't want to have on my tombstone the inscription, "She was a good duster." I would rather write bestseller books or ride a camel across the Sahara than stay home and vacuum.

—*Shirley Conran, writer*

I never use a score when conducting my orchestra. Does a lion tamer enter a cage with a book on how to tame a lion?

—Dimitri Mitropoulos, conductor

To be completely
convincing is,
in effect, what
makes an artist.

—*Gary Graffman,*
pianist

I can't really
imagine that any
creative artist
wakes up and feels,
"How good I am!"
and "Look how
far I have come!"
because you know
yourself to be
up against your
limitations.

—Elizabeth Hardwick,
writer

As for famous men
who were not artists,
I am beginning to
be tired of them.
Those poor little
scoundrels who
are called great men
fill me with nothing
but overwhelming
horror.

—*Franz Liszt, composer*

The happiest of
all lives is a
busy solitude.

–Voltaire, writer

When you start
to learn the lines,
you think the
role's never
going to work.
You're all feet.
You're all hands.
You start to put
on a funny
voice, a funny
walk.

—*Elizabeth Franz,*
actress

I'd like to think that when I sing a song, I can let you know all about the kicks in the ass I've gotten over the years, without actually saying a word about it.

—Ray Charles,
singer

Braque always said
that the only thing
that counts in
painting is
the intention,
and that's true.
What counts is
what one wants
to do,
and not what
one does.

−Pablo Picasso,
painter

Greatness
breaks laws.

−Louise Nevelson,
sculptor

It is a queer thing, but when you really feel your role, the impression you make on the audience is poorer.

—*Konstantin Stanislavsky, director*

I don't want a machine in a dancer. The flaws
of an individual are sometimes so marvelous.

—*Leon Danielian, choreographer*

I have always believed that women should resent and refuse to accept all the gratuitous insults that men impose upon them. The woman artist is especially vulnerable and could be robbed of her confidence.

—*Alice Neel, painter*

Black was never a color of death or terror for me.
I think of it as warm and generative.

—Clyfford Still, painter

Those great
rock 'n' roll
experiences are
getting harder
and harder to
come by,
because they have
to transcend
a lot of drug-
induced stupor.
But when they
occur, they are
sacred.

−Peter Townsend,
musician

I do not want to go
until I have
faithfully made the
most of my talent
and cultivated the
seed that was
placed in me.

—*Käthe Kollwitz,*
visual artist

I never force
devout sentiment
and never
compose
hymns or
prayers except
when I am
involuntarily
overwhelmed
by it,
so it is usually
a real, genuine
devoutness.

—Franz Schubert,
composer

Even in the most
sophisticated
person,
it is the
primitive eye
that watches
the film.

−Jack Nicholson,
actor

Music that is born
complex is not
inherently better
or worse than
music that is born
simple.

—Aaron Copland,
composer

Sometimes I see it
and then paint it.
Other times
I paint it and
then see it.
Both are impure
situations, and
I prefer neither.

−Jasper Johns,
painter

On a new play no
one knows what
the "famous"
moments will be.

—*Linda Hunt, actress*

The Age of Iron began many centuries ago. Today the door is wide open for this material to be forged and hammered by the peaceful hands of the artist.

—*Julio Gonzalez, sculptor*

All the critics have said the same thing: "It is time for Simenon to give us a big novel, a novel with twenty or thirty characters." But my big novel is the mosaic of all my small novels.

—*Georges Simenon, writer*

However perfect you make the instrument,
it won't resound, unless you can feel.

—*Ellen Terry, actress*

Everywhere at every time in the world, the artist has had to be a strong person in order to retain his own individuality.

—*Sergei Shutov, painter*

I like your work at a distance, but when I come near
I'm always disappointed to see
that there are objects.
—*Abstract expressionist,*
to the painter Andrew Wyeth

In the fiddler's house,
all are dancers.

—*French proverb*

It's far more enjoyable
pretending to be a doctor
than actually being one.

—*Cedric Hardwicke, actor*

When I'm singing,
I feel like I feel
when you're
first in love,
when you're
touching someone.
A lot of times
when I get off the
stage, I want to
make love.

—Janis Joplin,
singer

I've learned what
"classical" means.
It means
something that
sings and dances
through sheer joy
of existence.

—Gustav Holst,
composer

Photographers are more interested in capturing life's stage than in taking up the stage.

—*Cecil Beaton,*
photographer

Believe me,
the living artist needs
an advocate.

—*Howardena Pindell,*
painter

What artists are struggling with now is how to be
creative without all the trappings of the Wagnerian ego.

—*William Irwin Thompson, writer*

I became frightened of my capacities, and frightened
of the responsibility of the talent I was apparently
born with.

—*Erik Bruhn, dancer*

My definition of
art is that it isn't
commercial.
Almost everything
else is.

—*Maren Hassinger,*
painter

Creative work
makes me happy,
but the
subsequent
pauses for rest
are all the
more painful,
for then one
begins to think
things over.

—Hugo Wolf,
composer

If the director
doesn't recognize
what a courageous
thing the actor is
doing by touching
on some
emotionally tender
spot, then the
actor will be wary
of doing that.

—Arthur Penn,
director

All my concerts
had no sounds
in them:
they were
completely silent.
People had to
make their own
music in their
minds.

—Yoko Ono,
musician

A great part of me is
steeped in a personal
tradition of finding
things to create.
So I don't think I'll
ever run dry.

—*Charles Fuller,*
playwright

Dance is everything that's beautiful,
everything that's difficult.

—*Robert Joffrey, choreographer*

I might have painted if I had lived in an atmosphere of art, but in America everything resolves itself into the getting of money and selling a poor article instead of a good one.

—*William Morris Hunt, painter*

It's a mistake to talk about discrimination in the art world, since it is really about discrimination in the real world.

—*Mary Weatherford, painter*

In order to function,
I need a public.
We all need it. And
there is none of us
who is free
of that anxiety.

—*Eugene Istomin,*
pianist

I intend to find out
something of the
nature of the world
through seeing.
Or maybe I only
intend to prolong
my delight in
seeing.

−Gretna Campbell,
painter

I have chosen to paint our own age because that is what I understand best, because it is more alive, and because I am painting for living people. So of course my pictures will be rejected.

—*Frederic Bazille, painter*

Artists involved in politics hope their art will change the consciousness of people, but that's putting the cart before the horse. As Bertolt Brecht said, "Food before aesthetics."

—Tim Rollins, visual artist

I have never
thought of being
anything less
than great.

—*Francesca Corkle,*
dancer

To play great music,
you must
keep your eye on
a distant star.

— *Yehudi Menuhin,*
violinist

I use naive imitation. This is not because I have no imagination or wish to say something about the everyday world. I imitate because I want people to get accustomed to recognizing the power of objects.

—*Claes Oldenburg, visual artist*

Learn to trust your own judgment, learn inner independence,
learn to trust that time will sort good from bad—
including your own bad.

—*Doris Lessing, writer*

A playwright
knows that
what is most
private in
her heart of
hearts is also
the most
astonishing.

—*Tina Howe,*
playwright

After leaving school
students often
don't work
because there's
no reason to
work.
Nobody
pays attention
any more:
so there seems
no reason to
press on.

—Bruce Boice,
painter

If we had to say
what writing is,
we would have
to define it
essentially as an
act of courage.

–*Cynthia Ozick,*
writer

The public doesn't want
new music;
the main thing that it
demands
of a composer
is that he be dead.

—*Arthur Honegger,*
composer

If men cannot
always make
history have a
meaning,
they can always
act so that their
own lives have
one.

—*Albert Camus,*
writer

I see myself as
just kind of a
New England
character who's
living off in the
woods with
her creatures.
Not worrying,
not minding
at all being
eccentric.

—*Maxine Kumin,*
writer

One must be honest.
No veils! No shams!
Naked, all things
reduced to their worst.

—Jean Dubuffet, painter

Art is not a pastime
but a priesthood.

—*Jean Cocteau, writer*

Be yourself.
The world worships the original.

—Ingrid Bergman, actress

Great writing
may be conjured by
great injustice.

—*Lance Morrow, writer*

I love the homework,
the research,
the solitude that goes
into a part.

—*Bob Hoskins, actor*

For me, even an
arabesque has to be in
character.

—*Carla Fracci, dancer*

All young actors first work through tension,
because it's the only thing they know.

—*Lawrence Olivier, actor*

The creative power which bubbles so
pleasantly in beginning a new book quiets down
after a time, and one goes on more steadily.
Doubts creep in. Then one becomes resigned.

—Virginia Woolf, writer

When there is no
understanding and
no trust between
you and your
partner, it doesn't
matter how well
you dance.
It becomes like a
two-headed eagle.

—Rudolf Nureyev,
dancer

Avoid words that
can't even scratch
at the hundred
hidden meanings
in objects and
structures.

−*Eduardo Paolozzi,*
sculptor

In a moment of grace, we can grasp eternity in the palm of our hand. This is the gift given to creative individuals who can identify with the mysteries of life through art.

—*Marcel Marceau, actor*

I've never quite believed that one chance is all I get.
Writing is my way of making other chances.

—Anne Tyler, writer

It's impossible to
know the play too
well. You've got to
feel the play as
deeply as the writer.
You must dwell
on it.

—*Marshall W. Mason,*
director

The best music
always results
from ecstasies of
logic.

—Alban Berg,
composer

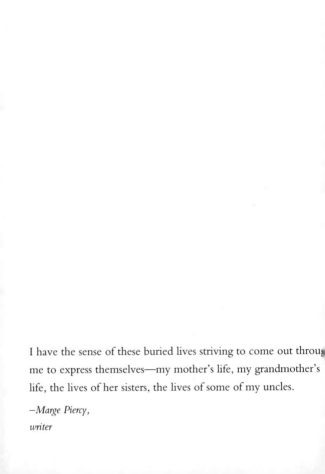

I have the sense of these buried lives striving to come out through me to express themselves—my mother's life, my grandmother's life, the lives of her sisters, the lives of some of my uncles.

—*Marge Piercy,*
writer

Painting is a
way to
knowledge.
So are all
the arts.

—*Morris Graves,*
painter

Polyphony,
flatted fifths,
half-tones—
they don't
mean a thing.
I just pick up
my horn and
play what I
feel.

–*Jack Teagarden,*
musician

If I had to give
young writers
advice, I'd say
don't listen to
writers talking
about writing.

—Lillian Hellman,
playwright

You paint the way you have to in order to *give*, that's life itself,
someone will look and say it is the product of knowing,
but it has nothing to do with knowing, it has to do with giving

—*Franz Kline, painter*

In Verdi, the high notes you anticipate with pleasure. But in Wagner they are like a whole building coming down on top of you.

—*Placido Domingo, singer*

Either I have to
know everything
about a place,
so that I don't
have to think, or
else I must never
have seen it
before, so that
I'm wide awake
to everything as
a stranger.

—*Eudora Welty,*
writer

The spectacle of
the sky
overwhelms me.
I'm overwhelmed
when I see,
in an
immense sky,
the crescent of
the moon, or
the sun.

—Joan Miró,
painter

When uncomfortable
questions are raised
by art, or when
it speaks with the
voice of the
disenfranchised,
the larger audience
is disturbed.

—*Martha Rosler,*
painter

I'm rather
hostile toward
audiences—
I don't much
care for large
bodies of
people collected
together.

—Harold Pinter,
playwright

You can't quite relate to being known by people who you don't know. Your writing's out there, and you're just at home with the cats.

—Bobbie Ann Mason, writer

Hot can be cool, and cool can be hot, and each can be both. But hot or cool, man, jazz is jazz.

—*Louis Armstrong, musician*

I love music passionately, and because I love
it I try to free it from barren traditions that stifle it.

—*Claude Debussy, composer*

When the actor is at a peak, the audience is in perfect harmony. All their attention is focused on one spot, like in a meditative experience, and I'm sure they're all breathing together.

—Ellen Burstyn, actress

It is not hard to compose,
but it is wonderfully hard
to let the superfluous notes
fall under the table.

–*Johannes Brahms,*
composer

I'll tell you the
most important thing
about acting,
and that's honesty.
If you can fake that,
you've got it made.

—George Burns,
actor

What I want to do is
to distort the thing
far beyond
the appearance,
but in the distortion
to bring it back
to a recording
of the appearance.

—*Francis Bacon,*
painter

Now any writer is
hard put to shock
the public.

—Naomi Mitchison,
writer

The artist does not
let himself be
transformed into
the man he presents,
so that nothing of
himself is left.

—*Bertolt Brecht,*
playwright

Don't ask: what
does it mean?
A painting cannot
speak.

—Josef Peeters,
painter

Just to get a
hundred pounds
of new clay,
such labor!

—*Mary Frank,*
visual artist

I used to think,
I can't be mad,
because nobody's
put me away;
therefore,
I'm a genius.

—John Lennon,
musician

Nothing but
the astonishing
is beautiful.

—*André Breton, poet*

as riding a fine line between beauty and ugliness. Coming from painterliness and tonality I was exhilarated to find my work aggressive and absurd.

—*May Stevens, painter*

A horse running
has twenty legs,
not four, and
their movements
are triangular.

– *The Futurists*

If I play Tchaikovsky I play his melodies and skip his spiritual struggles. I have to know just how many notes my audience will stand for.

—*Liberace, pianist*

Sometimes it's
frightening to me
that I see beauty in
pollution,
I see beauty in
factories spouting
black smoke.

−*Cynthia Mailman,*
painter

Acting is not imitation,
it is revelation.

−*Peter Hall,*
director

There are certain mysteries, certain secrets
in my own work which even I
don't understand, nor do I try to do so.

—Georges Braque, painter

I think the longevity of the artist depends on always being willing, able, and unafraid to step into unknown territory.

—*Maria Irene Fornes, playwright*

Writing involves
a commitment
greater than illness.

—*Bernard Malamud,*
writer

The artist is the
confidante of nature.

—*Auguste Rodin,*
sculptor

Bessie Smith showed me
the air and taught me
how to fill it.

–Janis Joplin, singer

Writing is a noble privilege compared with the lot of most people, who live like parts of a machine, who live only to keep the gears of society pointlessly turning.

—*Blaise Cendrars, writer*

Conductors must give
unmistakable and
suggestive signals to
the orchestra—
not choreography to
the audience.

—*George Szell,*
conductor

I seem to have an
awful lot of people
inside me.

—Edith Evans,
actress

A writer is
in the end
not his books,
but his myth—
and
his myth
is in the keeping
of others.

—V. S. Naipaul,
writer

The ordinary logic
of the real world
is pushing us to
catastrophe. What
the artist is trying
to do is to get free
of that doom.

—*Bram van Velde,*
visual artist

It's frightening to feel that
you always have to sing better
than yourself.

—*Martina Arroyo, singer*

...ink with what difficulty a medium tries to establish contact with a spiritual force. There is the ritual of the séance, the darkened room. The theatre works on a similar principle.

—*Charles Marowitz, director*

When I play, I make love—
it is the same thing.

—*Artur Rubinstein, pianist*

I always use people I know.
I always tell them they'll
make a marvelous story.

—*Beryl Bainbridge, writer*

Nobody's got any objection to even iambic pentameter if it comes from a source deeper than the mind—that is to say, if it comes from the breathing and the belly and the lungs.

—*Allen Ginsberg, poet*

The director is the objective person between
the audience and the play.

—Lloyd Richards, director

The real difficulties
are interpreting
music, not the
sheer technical
problems.
The interpretive
problems come
from the limitations
of one's self
as a person.

−Janet Baker, singer

My wastepaper basket
is filled with works
that went a quarter
through and which
turned out to be
among those things
that failed to engross
the whole of me.

—Thornton Wilder, writer

I was an instrument,
like other dancers.
My motivation was
to be as pliable and
as receptive as
possible.

—*Sono Osato, dancer*

The faster you go, the
more control there is.

−Gerald Arpino, dancer

Film work is concentrated and not usually very sustained. It is, in fact, not unlike very bad sex: it's all over in thirty seconds, and it's an hour before you can do it again.

—*Simon Callow, actor*

The subject matter is the paint,
and the paint speaks of human needs.

—*Joan Snyder, painter*

Give me the best instrument in Europe, but listeners who do not feel with me in what I am playing, and all my pleasure is spoilt.

—*Wolfgang Amadeus Mozart, musician*

Books are
stronger than
frontiers.

—Günter Grass, writer

I intend to reflect the way the monster manifests itself in everything from performance to *cloisonné*, in the hope that seeing it in its many forms will trigger us to stopping it.

—*Ellen Van Fleet, visual artist*

If I were completely blind now and knew where the colors were on my palette, I could express myself.

—*Homer Dodge Martin, painter*

The artist as celebrity
defeats the possibility of
the artist as celebrant.

—*David Spangler, writer*

Having relatively recently acknowledged the spirituality of my being, I intend to allow this spirituality an ever greater place in my art.

—*Susan Brenner, painter*

It is a very difficult thing
for an actor who knows
exactly what he is going
to say to behave exactly
as though he didn't.

—*William Hooker Gillette,*
actor

Goya goads his
pilgrims across dark
chasms. What leaps
to the eye is a
demoniac black
that pours in
deepest despair over
the palette, midst
torrents of gray and
white and ochre.

—*Mordecai Ardon,*
painter

The discomfort you feel in the face of something that's not quite original is for me the subject matter.

–*Sherrie Levine,*
painter

The hardest thing for me
is to find a renewed
youth each night.
The dancing, as
strenuous as it is,
is the least of it.
What takes the energy
is finding something
new within.

—Jorge Donn,
dancer

The colors in a painting
are not the same thing as
the stuff packed in tubes.
The artist's palette is no
mere physical and
impersonal thing:
it is a sort of magical
laboratory.

—*Arturo Fallico,*
writer

I want my work to
demand your
attention,
because I can get it
in no other way.

—Harmony Hammond,
visual artist

As a young actor, I remember that feeling of power, that awareness of keeping an audience quiet by a pause or a look implying that I was going to do something—and then doing it.

—*Alec McCowen, actor*

You ought to be able to say that a painting is as it is, with its capacity to move us, because it is as though it were touched by God. But people would think it a sham. And yet that is what's nearest the truth.

—*Pablo Picasso, painter*

When I was in my studio,
I didn't give a damn
what sex I was.
Nor did I feel
I couldn't learn
from any male
artists either.
I thought,
art is art.

—Alice Neel,
painter

Any short account
of a novel seems
ridiculous by the
side of the real
thing.

−Angus Wilson,
writer

If writers had to wait
until their precious
psyches were
completely serene,
there wouldn't be much
writing done.

—*William Styron, writer*

Each new part is a
new problem. That's
what makes the
theatre interesting—
the problems rather
than the "glamour."

—Edith Atwater, actress

I love music more
than myself—but it is
vastly more loveable
than I.

—*George Szell,*
conductor

A painted picture is
like a vehicle.
One can either sit in
the driveway
and take it apart or
one can get in it
and go somewhere.

—*Mark Tansey,*
painter

The notes I handle no better than many pianists. But the pauses between the notes—ah, that is where the art resides!

—Artur Schnabel, pianist

Why does the dancer work daily over every muscle of his body? And why may the dramatic actor do nothing, spend his day in coffee houses and hope for the gift of inspiration in the evening?

—*Konstantin Stanislavsky, director*

As a woman, had I lived in ancient Greece my fantasies would never have been realized. This has dampened my interest in the Greeks, but not my fantasies.

—*Louise Stanley, painter*

One only invents
that which is.

–Jean Fautrier, painter

I've never bothered painting ugly things in life. People strugglin[g] having difficulty. You meet that when you go out, and then yo[u] have to come back and see the same thing hanging on the wall.

—Alma Thomas, painter

I chronicle, I do not judge.

—John Singer Sargent, painter

I should never be
able to write a real
autobiography;
I always end up by
falsifying and
fictionalizing—
I'm a liar, in fact.

—*Alberto Moravia,*
writer

If you're an exceptionally gifted woman,
the door is open. What women are fighting
for is the right to be as mediocre as men.

—*Grace Hartigan,*
painter

I'm a little uneasy
when writing
doesn't come hard.
It's better for me
when I have to forge
the will to do it
on a given day.

—*Norman Mailer,*
writer

I have been drawing
large scale
phallic/screws,
nine feet high and
thirty feet long.
The phallus and all
it stands for is
not exclusively a
male image.

—*Judith Bernstein,*
painter

I think in sounds.

—*Maurice Ravel,*

composer

The element of risk is part of
the challenge of watercolor.

—*Robert Blair, painter*

Directors are much more prepared to accept men defending what they've written. If women do it, they're considered difficult, whereas men can be aggressive and everyone thinks this natural.

—*Dorothy Hewett, playwright*

Art is research into the unknown,
adding a little to the fund built up
by earlier generations.

—*Olle Baertling,*
painter

Discovery consists of
seeing what everybody
has seen and thinking
what nobody has
thought.

—*Albert Szent-Gydorgyi,*
writer

I enjoy colors more than words, shapes more than sentences. When in the streets, I instinctively notice the size and color of the letters on signs, not their directives.

—*Nell Blaine, painter*

Any book I write starts with a flash but takes
a long time to shape up.

—*Robert Penn Warren, writer*

There are some
artists who want
to tell all,
but I feel it is
more shrewd to
tell little.

—Mark Rothko,
painter

Feminism taught me not to worry about what I was "allowed" or "not allowed" to do as a serious artist.

—*Miriam Schapiro,*
painter

My parents missed
the chance of buying
the Impressionists
cheap because they
didn't like them.
I buy only what I
don't like.

—*Anonymous art collector*

I used to hold the whole of a book in my head. Now if I take a walk whilst I am writing, I have to hurry back and make a correction, before I forget it.

—*Evelyn Waugh, writer*

I hardly ever paint people unless I'm rather in love with them.

—*Sylvia Sleigh, painter*

epression in people recovering sight after many years of blindness
seems a common feature of the cases. One man found the world
drab, and was upset by flaking paint and blemishes on things.

—*R. L. Gregory, writer*

I write to find out.

—*Bill Manchester, writer*

Yes, I'm fifty-three years old, but I don't think about it. I only think of what I must do tomorrow—that I must dance *Swan Lake*, that I must dance *Sleeping Beauty*.

—*Margot Fonteyn, dancer*

I believe in
everlastingness.
I never finish a
painting—
I just stop working
on it for a while.

—*Arshile Gorky,*
painter

I have a lover's
insight or a lover's
blindness for work
just now.
Because these
colors about me
are all new to me,
and give me an
extraordinary
exaltation.

—Vincent van Gogh,
painter

Songs have
overthrown kings
and empires.

–Anatole France,
writer

For me, writing is a
question of finding
a certain rhythm.
I compare it to the
rhythms of jazz.

—*Françoise Sagan,*
writer

The playwright, along with any writer, composer, painter in this society, has got to have a terribly private view of his own value, of his own work.

—*Edward Albee, playwright*

I have known, everyone knows, everyone will
continue to know, that two and two make four.
But this irritates me; it quite upsets my way
of thinking.

−Paul Gauguin, painter

The wastepaper basket
is still the writer's
best friend.

—*Isaac Bashevis Singer, writer*

I get a restlessness in the morning when I get up and I'm working. Anyone around or very near to me can compute my restlessness. I become another person.

I have to work.

—*Rosa Guy, writer*

I should be sorry, my lord, if I have only succeeded in entertaining them. I wished to make them better.

—George Frideric Handel, composer

The source of my painting is in the unconscious.
I have no fears about making changes or destroying
the image, because the painting has a life of its own.

—*Jackson Pollock, painter*

Let the audience tear up
the seats and hurl them
at the stage and want
to kill the actors. If the
audience is reached and
their reaction is to be
furious, how wonderful,
how healthy!

—*Hume Cronyn,*
actor

The fact that artists
are workers—
a real part of the
working class—
is much too
embarrassing for
most of us to
acknowledge.

—Carrie Mae Weems,
painter

In literature, as in
love, we are
astonished at what
is chosen by others.

—André Maurois,
writer

My work and
activities can be seen
as a circus
performance.

–Carl Reuterswärd,
installation artist

Music is a moral law.
It gives a soul
to the universe.

—*Plato, philosopher*

began to look on my pictures as something I must finish in order to get so much money, and the spirit of the artist died away within me. I was like a bee trying to make honey in a coal hole.

—*Washington Allston, painter*

Most writers write
haphazardly.
The actor is fighting
unjustified words
all the time.

—Marlon Brando,
actor

Music and poetry together are a combination capable of realizing the most mystic conception.

—*Gustav Mahler,*
composer

I'm just a bespectacled
novelist who dreamed
this all up.

—*Paul Theroux, writer*

ome years ago, I noticed that the most taboo thing you could say about an abstract painting was that it was decorative. After some thought, I decided that this taboo was both sexist and racist.

—Joyce Kozloff, visual artist

The mass crushes beneath it everything that is different, excellent, individual, qualified, and select. Anybody who is not like everybody runs the risk of being eliminated.

—*José Ortega y Gasset, philosopher*

I have no master and shall never have any.

—*Winslow Homer, painter*

Any woman artist
who says there is
no discrimination
against women
should have her
face slapped.

—*Lee Krasner,*
painter

Only a fool imitates.
It is better to do bad
work of one's own.

—Georges Bizet,
composer

I believe that every
creator must
eventually attempt
what may be termed
a revolt, whether
he wants to or not.

–*Jiri Kolar,*
painter

If I walk on the
stage with a
certain attitude,
people will
understand
immediately.

—*Geraldine Page,*
actress

Why is life different
when the singing
stops?

–*James Reeves,*
writer

For an artist,
a cathedral that is
falling down has
all those bricks
with which
to build!

—James Hubbell,
visual artist

I never practice; I always play.

—Wanda Landowska, pianist

A big stone on a deserted beach is a motionless thing, but it sets loose great movements in my mind.

–*Joan Miró, painter*

Work begets work.

–Tom Moore, director

Sometimes I see the world as one gigantic
sewn image, held together with small,
neat stitches.

—*Sherry Brody, visual artist*

Art is a proven meditation.

—*Wayne Thiebaud, painter*

Just listen with the vastness
of the world in mind.
You can't fail to get the
message.

−Pierre Boulez, conductor

Every story is
completed by
the reader.

—*Grace Paley, writer*

Works of art express the deepest inwardness.

—Theo van Doesburg, painter

Over the door of
the sacred tepee,
they painted the
flaming rainbow.
It took them all day
to do this, and it
was beautiful.

—*Black Elk,*
medicine man

Suppose no one
asked a question.
What would
the answer be?

—*Gertrude Stein,*
writer

Ends always
give me trouble.

—*E. M. Forster,*
writer